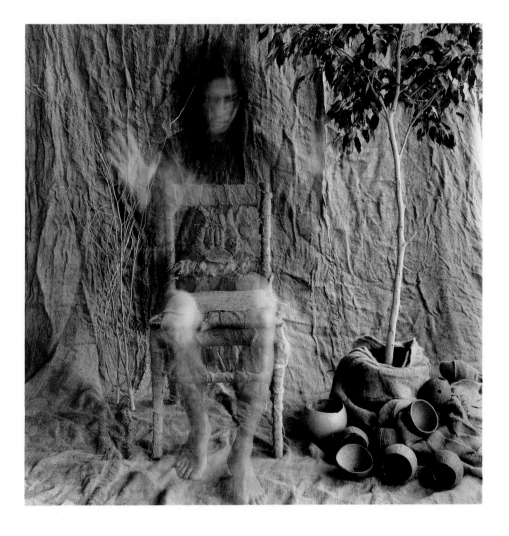

Dedicated to my loving and supportive family: my wife Frances, my son Ayinde and daughter Chinwe, and to my mother Gloria.
—A.C.

Albert Chong and The Friends of Photography gratefully acknowledge the Vice Chancellor for Faculty Affairs at the University of Colorado, Dr. Albert Ramirez, for his generous support of this publication in the form of an IMPART grant (Implementation of Multicultural Perspectives and Approaches in Research and Teaching).

We are also indebted to Polaroid Corporation for its generous support in recognition of Albert Chong's creative work.

UNTITLED 57.

This is the fifty-seventh in a series of publications on photography by The Friends of Photography. Previous titles are still available. For a catalog, write to: Publication Sales, The Friends of Photography, 250 Fourth Street, San Francisco, California 94103.

First edition.

©1994 by The Friends of Photography.

ISSN 0163-7916; ISBN 0-933286-63-5.
Library of Congress Catalog No. 93-079511.

Edited by Michael Read.
Designed by Toki Design, San Francisco.
Editorial assistance provided by Barbara DeLollis, Lisa Henry and
 Cassandra Kovel.

Distributed by The University of New Mexico Press, Albuquerque.

Front cover: RED ALTAR, 1987
Back cover: THRONE FOR THE GORILLA SPIRIT, 1992
Title page: NATURAL MYSTIC, HERALDING IMAGE
 OF THE I-TRAITS SERIES, 1980

Facing page: LEANING ON THE PALO, 1982-1984

ANCESTRAL
DIALOGUES

∞ THE PHOTOGRAPHS OF ALBERT CHONG

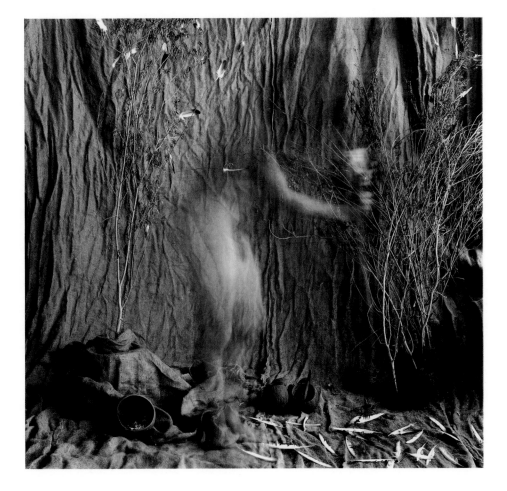

THE FRIENDS OF PHOTOGRAPHY ∞ SAN FRANCISCO

UNTITLED 57

∞ IN THE EYES,
MEMORY LIES

By Quincy Troupe

∞ There is magic, music, myth and mystery in the photographs of Albert Chong because he sees and creates it within his frames; after all, the whole point of photography is seeing and Albert Chong sees very well. But Chong also interprets and feels what is before him in a magical and musical way. The way he composes within his photographic frame is similar to a musical composition—many of his prints are a little off center in the same way that much of great music is played off the beat. Like searching on the piano for the flatted 5th, music is created by Chong's constant interplay with dark and light. Sometimes dissonant, sometimes luminous, sometimes rough around the edges, his creations are always challenging for the eye.

For this artist, the process of photography is very often just a small part of a much larger, more complex idea and vision. Through the creation of his installations and assemblages, Chong compels us to look at commonplace objects and images anew: a rope around a small animal skull resting on a bed of cowrie shells; a photograph—the photographer's father—lying on the seat of a chair surrounded by severed strands of dreadlock hair and other objects; a passport picture of the photographer himself with shells arranged beneath his face; a baboon's skull, placed on a copper covered chair, or resting on a shrouded table. Feathers and severed wings. Ashanti stools and chairs. Amulets. Eggs. Something that looks like a mummified baboon's head.

Mystery. Magic. African black magic. Dare I say Voodoo and Santeria rituals caught and fixed in photographic celebrations that empower ordinary objects and transfix the viewer? Throughout, our visual senses are heightened by this process of transmogrification and in the end, transmuted by what he places before us.

Chong's photographs are ultimately a very personal and poetic invocation of the African and Chinese traditions that he grew up with in his native Jamaica. They are highly ritualized, improvised narratives that make both religious and secular connotations. They feed the spirits of both ancestral and living appetites. They illuminate commonplace elements that are, through his magical, shamanistic eyes, transmogrified and transformed into objects of worship.

Chong consistently uses objects that are associated with African and West Indian culture in his assembled photographs, organic items such as cowrie shells, bird claws, feathers, or even fruit or coconuts. By introducing these things over and over again in his art, he extends their iconographic impact into a much larger, outside world. Thus, it is a spiritual and cultural quest that Chong has embarked on, a personal journey to the core of himself and of his spiritual engagement. The Jamaican religious practice of Obeah and its Cuban counterpart Santeria have had a profound impact upon the art of Albert Chong, as can be seen in his use of

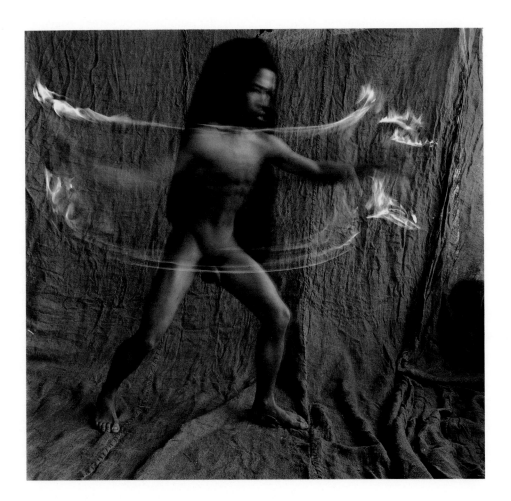

THE FIRE KEEPER DANCING WITH THE FLAMES, 1982-1984

power objects such as small animal skulls, bird feathers and cowrie shells. In using these objects, Chong seems to draw no distinction between his art and the life he lives but finds, instead, a union or fusion between his art, life and his spiritual practices.

Because these religious practices come out of an African and West Indian oral tradition, Chong's photographic renditions can be viewed as an adaptation or transference of these belief systems into a visual iconography that is tailored for contemporary society. As cultural myths, legends, familial histories and value systems have traditionally been passed down from generation to generation through the spoken word in African and West Indian societies, Chong has created a visual language through his photographs that encodes and preserves the old stories, legends and myths for future generations.

Chong's photographs also blur the meanings of borders, because they urge the viewer to unravel cultural references that are Western, African and Asian in origin. This can be seen most clearly in the image *Jesus, Mary and The Perfect White Man*. This photograph contains the ceramic head of a white man with blond hair, a nicked and scarred figurine of Jesus, a photo of a black woman, and a head bust of an angelic looking, young white girl; Chong, by juxtaposing all these images in one print, blurs the traditional meaning of all of them. Who is "Mary" in this photograph—the black woman or the young white girl? And what is their relationship to the nicked and scarred figure of Jesus lying prone there with a bird feather across his stomach? And what is Chong trying to evoke or tell us with his placement of the severed head of the white man in the corner of the photograph? For me, traditional borders and meaning are blurred in this photograph. It is also very, very political—as most of his photographs are political—because of the shamanistic attributes with which

he infuses it and because of his desire to transform the objects he photographs into power images of divination. Herein lies the political undertone in Chong's art: through his transforming eye, the still-life becomes an apocalyptic smorgasbord of ancestral and cultural references and evokes oppression, colonialism and ultimately the triumph of the artist's vision. Power emanates from these animistic and shamanistic divinations that he puts before us.

Still, in spite of the power, there is a randomness one feels here in Chong's still-life assemblages, a randomness that Chong brings together through a process of invention. It is sparked by the interaction between the objects he photographs, and it results in an expression of a power synthesis that finally becomes a dialectic. This synthesis comes out of Chong's experience of immigrating from Jamaica to New York City—Brooklyn, to be exact—where he attended art school and began to fuse his traditional Rastafarian beliefs with those of a Western art school. In the end, his Jamaican-based beliefs won out because Chong, himself a shaman, witch doctor, believes deeply in the improvisational mode of creating, of inventing his art as he goes along. He weaves spells in and through many of his photographs, which at their best are a synthesis of African-based animistic religions, including Santeria, Obeah, Yoruba, Rastafarianism and, in places, a hint of an overtone of Catholicism. Albert Chong invents his own cosmology.

Invention, for Chong, is an extension of many traditional African beliefs, which at their core embrace most things in the world and have the ability to open themselves up to other religions. His photographs do not proselytize; they are participatory and flexible, like African music. Improvisation is a key element in all of African art. Chong wants—indeed, invites—his viewers to participate in the assemblages constructed in his

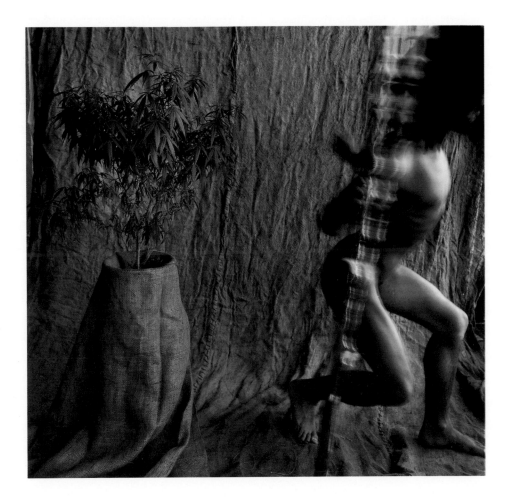

DANCING WITH THE PALO, 1982-1984

photographs, to add objects and subtract them in their mind's eye, to see things from their own point of reference and, hopefully, bring a sense of improvisation to the images and be touched by a magical, animistic, force.

Perhaps in his heart, Albert Chong is a Buddhist, a pacifist who feels that equality exists between the most minute organisms and the largest; this is a feeling I get when I look at many of his photographs.

The photographs never seem to start out with any preconceived notion of what they should be. Instead, they improvise their way toward completion in the same manner in which African-based music proceeds. It is a sharp instinct that determines the image. In the beautiful and stately *Throne for the Justice,* a shrine to his late father who died in 1989, one can sense Chong moving the strands of hair and the objects around in a deliberate attempt to synchronize them with his vision.

In his own self-portraits, which Chong calls the "I-Traits," he is naked and always in motion, a shadow ghost moving in and out of his smoke filled frames against a backdrop of burlap and tree branches. Chong seems to move rapidly, almost frenetically from idea to idea and from image to image in a daring display of complete confidence in his own abilities. In one, he is playing with his young son, Ayinde, who is suspended in space by Chong's feet, and it is an act of bonding. There is a strong sense of complete trust in the son for the father. Here, Chong manages to be both technician and shaman, the bearer of eggs and the sign of fertility.

These are stunning inventions. Clever. Tricky like a fox. In contemplation of this shadow-ghost-man passing through these frames, one might be induced to question its identity. Is it Chong himself, or the reinvention or reincarnation of Chong's father, or grandfather, or great-grandfather, or great-great-grandfather and on and on and backwards and forward to the future because of the presence of Ayinde suspended up there in the air? Or is that Ayinde's son, or his son's son, with Chong evoking all of this?

Yes, perhaps it is the future and maybe that is meant to be Ayinde—and not Chong himself—tossing his own son there into the smoky air. And what is a father to a son? To a daughter? What is he supposed to be? What does the child expect him to be? The Baron? The Baron Samedi? The keeper of the boneyard? Keeper of the memory? Is a son a clone of the father, the grandfather, the great-grandfather, the great-great-grandfather? And if a daughter, the mother, the grandmother, the great-grandmother, the great-great-grandmother? And on and on and back and back until the memory, the legacy comes forward to strike the son suspended up there in the air of that smoke-dusted photographic frame? The daughter, too, and the grandchildren, also way forward in the future and on and on and on and on?

Albert Chong's photography suggests all of this and more. It is about moths jumping out of a swirl of dreadlocks. A storm of hair swirling around. A cross standing in a glass of rum. About speeding tickets gotten on the sun baked roads of Jamaica, his father's memory as it is preserved in a passport picture. Spirits on the antelope throne. Interaction of spirits. Smoke. Ganja smoke blessing the throne of the gorilla's space. Ghost space. Yin and yang. Bad and good. Black and white. You and them. Us and them. I and I. Mystery and magic, music and ritual and one love for all. All there in those astounding still-life narratives full of *Powerlization,* in those shrines and thrones and ghost figures slipping through the mist. Transmogrification and transmutation in the improvisational eye of the shutter wizard himself. Albert Chong in the compositional flow. ∞

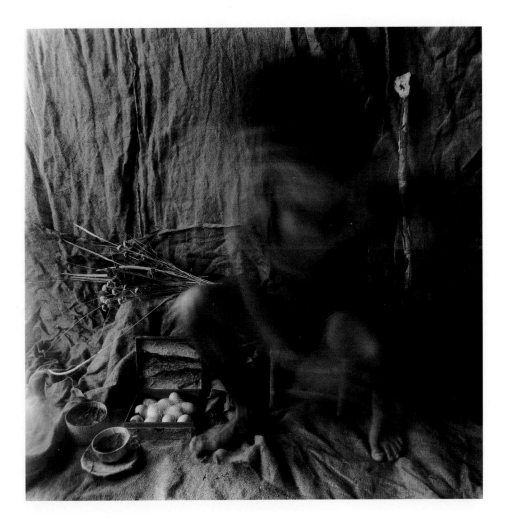

ANOINTING THE EGGS, 1982-85

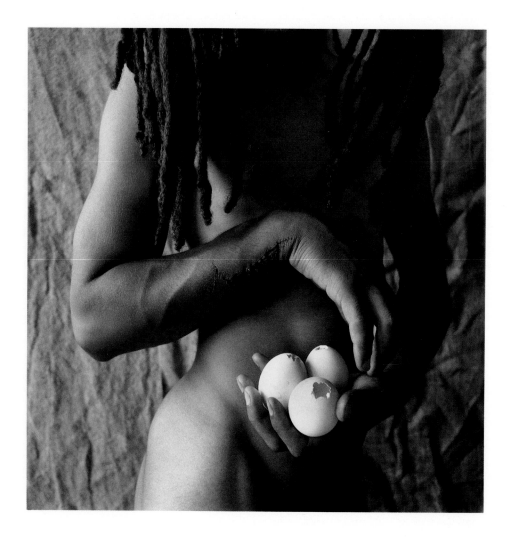

SELF-PORTRAIT WITH EGGS, 1985

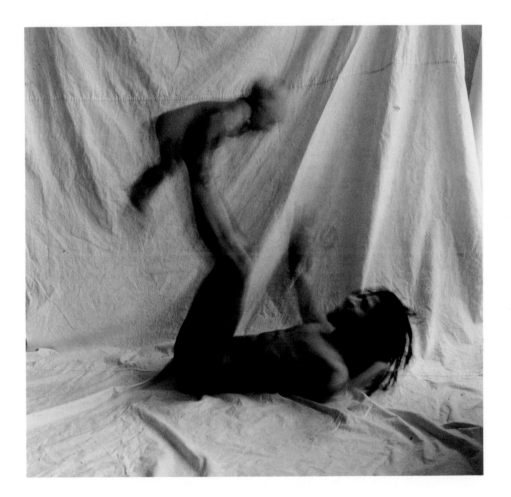

AYINDE AND I, BROOKLYN, N.Y., 1982

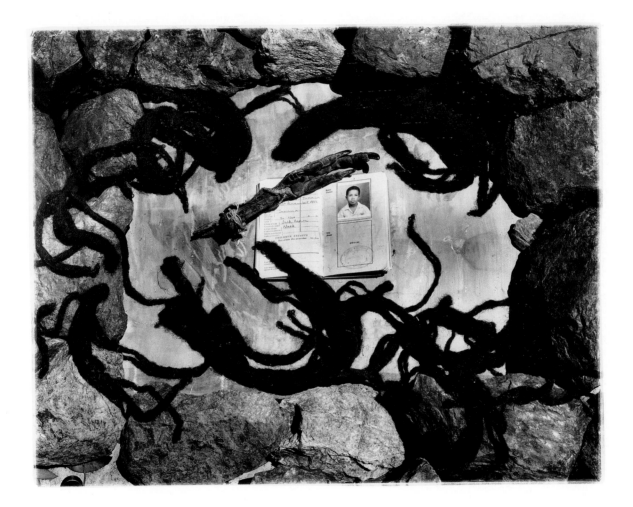

PASSAGES AND TOTEMS, 1990

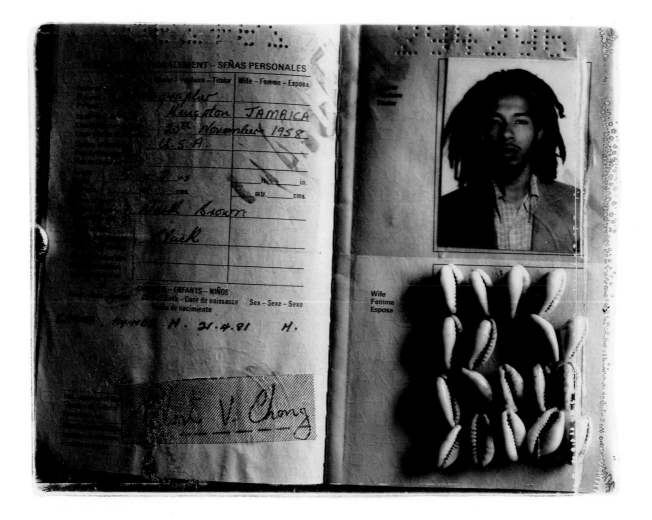

JAMAICAN PASSPORT, 1992

ROAD TRAFFIC LAW, 1990

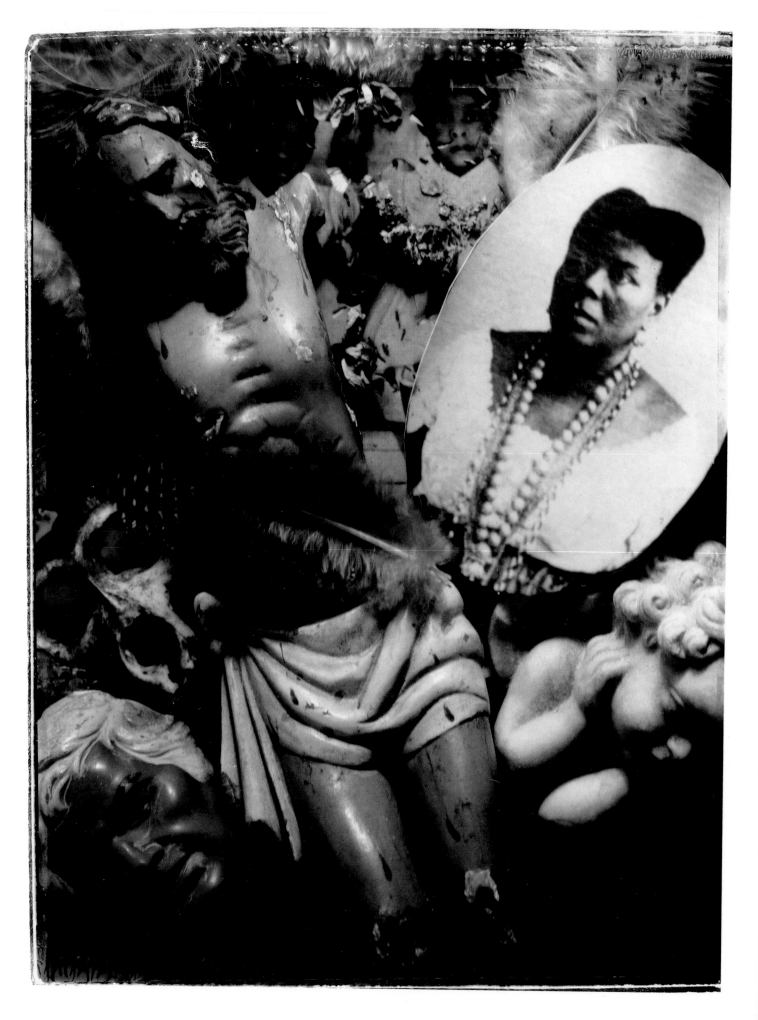

JESUS, MARY AND THE PERFECT WHITE MAN, 1989

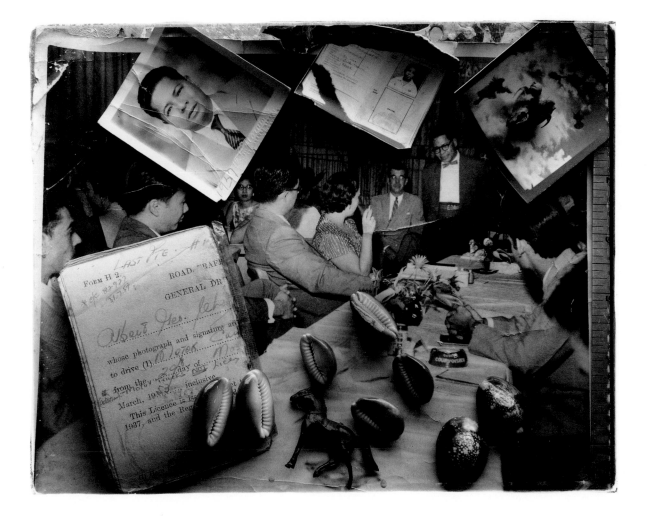

ADDRESSING THE CHINESE JAMAICAN BUSINESS COMMUNITY, 1992

∞ SEVERAL YEARS AGO, MY MOTHER SENT ME THE ONLY REMAINING PICTURE OF HERSELF AS A CHILD—AN OLD TORN AND YELLOWING PHOTOGRAPH OF THREE GIRLS. SHE IS THE SMALLEST CHILD IN THE PICTURE; THE OTHER TWO GIRLS ARE HER COUSINS. SHE ASKED ME TO REPAIR THE PICTURE. I COULD NOT HEAL IT, BUT I COULD REPHOTOGRAPH IT INCORPORATING THE TORN AREA OF THE IMAGE.

WHILE REPHOTOGRAPHING THE PICTURE, I BECAME OVERWHELMED BY THE SIMPLE BEAUTY OF THE IMAGE IN ITS RECORDING OF THREE SISTERS OF AFRICAN-CHINESE ANCESTRY AS THEY POISED THEMSELVES FOR HISTORY. JAMAICA WAS A MERE SIXTY YEARS OUT OF SLAVERY, AND SHE WAS AN ORPHAN AT THE TIME. HER FATHER, A CHINESE MUSICIAN, HAD DIED IN HIS SLEEP WHILE SHE PLAYED IN THE BED AROUND HIS BODY. HER MOTHER HAD LEFT JAMAICA WHEN SHE WAS AN INFANT TO LIVE WITH A MAN IN HONDURAS. SHE LEARNED OF HER MOTHER'S DEATH MONTHS AFTER THE FACT—THAT SHE HAD DIED OF HEMORRHAGING CAUSED BY FRIGHT, AS HER MAN TRIED TO PLAY A JOKE ON HER.

I THOUGHT OF THE IMPORTANCE OF THIS PHOTOGRAPH TO HER, HOW AS A CHILD IT MUST HAVE BEEN AN AFFIRMATION OF HER EXISTENCE, IF ONLY TO HER. I THOUGHT OF THE MANY OLD HISTORICAL PHOTOGRAPHS I HAD SEEN, AND OF THE FACT THAT FEW CONTAINED PEOPLE OF COLOR. I REALIZED IN THAT INSTANT HOW INCONSE-QUENTIAL THIS PHOTOGRAPH, AND THE LIVES THAT IT ILLUMINATES, WAS TO WHITE CIVILIZATION. I KNEW THAT I COULD NOT MERELY COPY THIS PICTURE, THAT IT MEANT TOO MUCH AND SHOULD REMAIN IN THE WORLD MEANING SOMETHING TO OTH-ERS. IN THIS SPIRIT OF CULTURAL RETRIEVAL, THE SISTERS EMERGED. ∞ A.C.

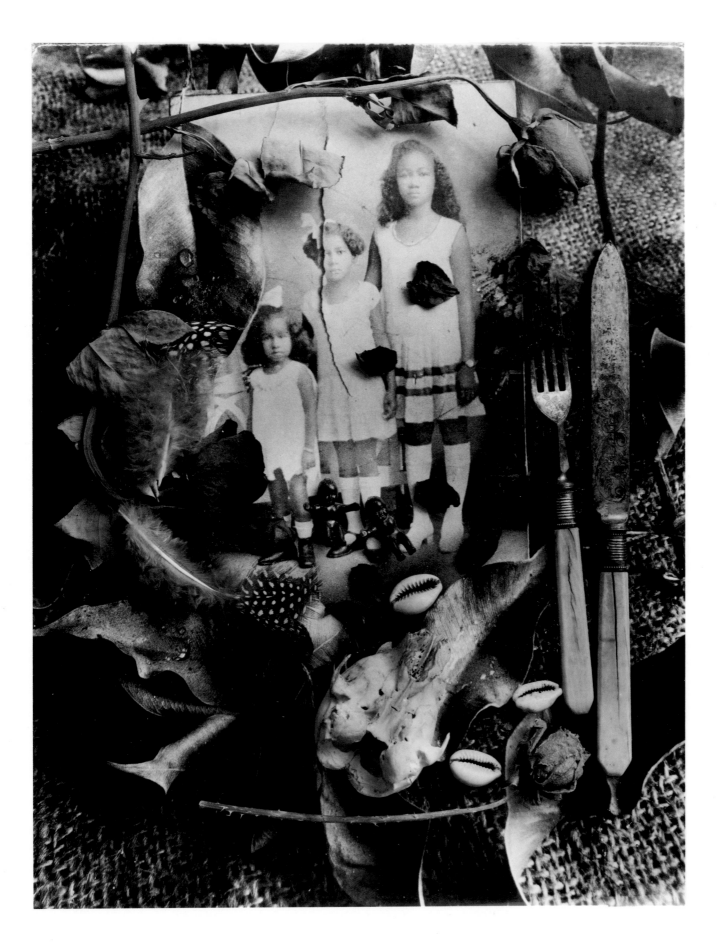

THE SISTERS, 1986

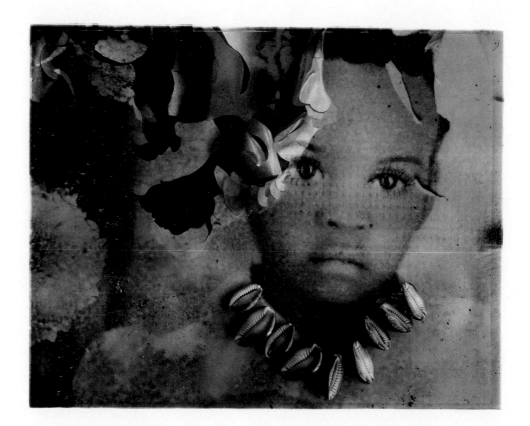

THE COWRIE NECKLACE, 1993

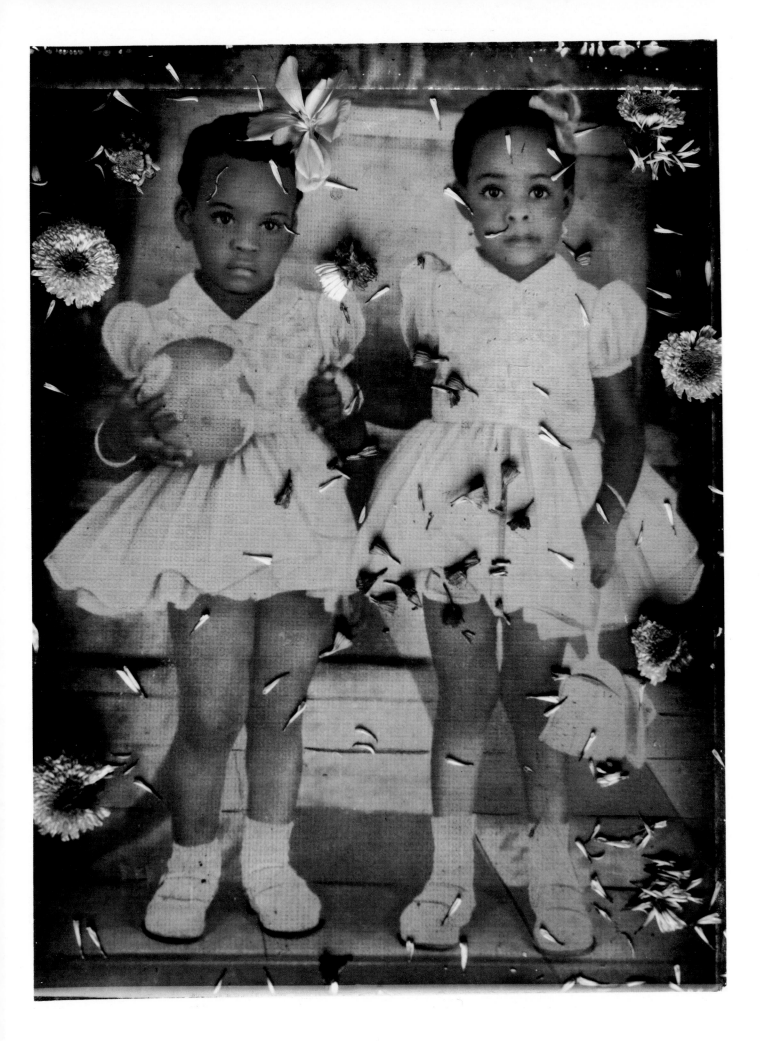

THE TWO SISTERS, 1986

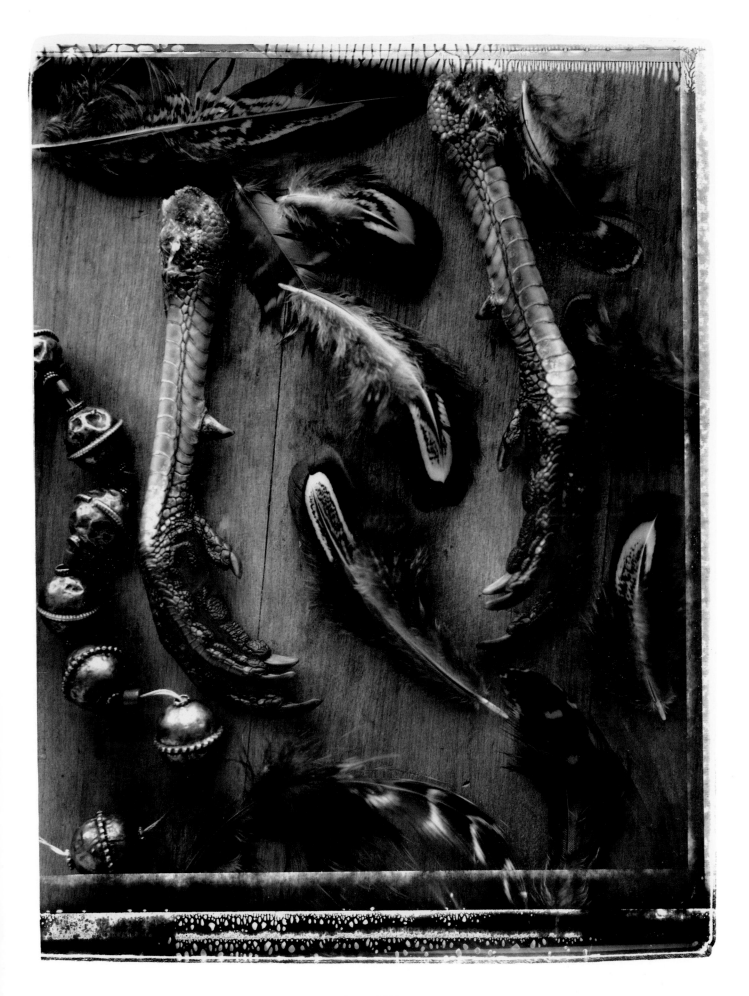

OBEAH, 1987

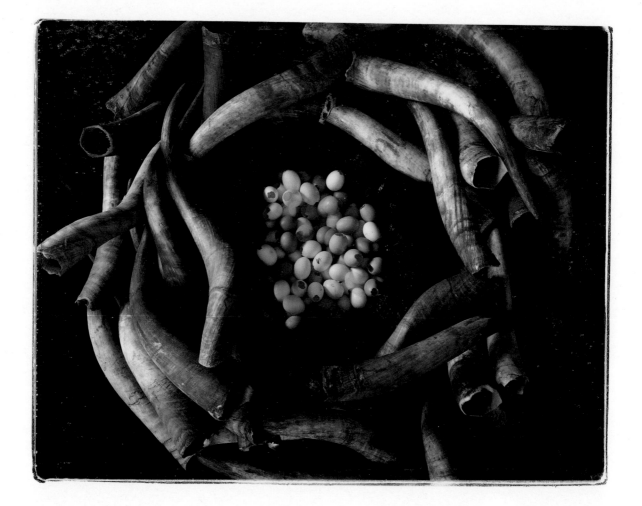

zLonghorn Nest with Eggs, 1992

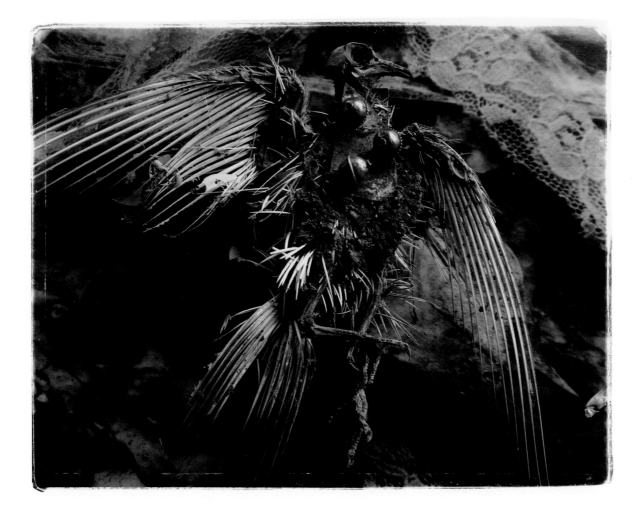

PIGEON AND THREE SILVER BALLS, 1987

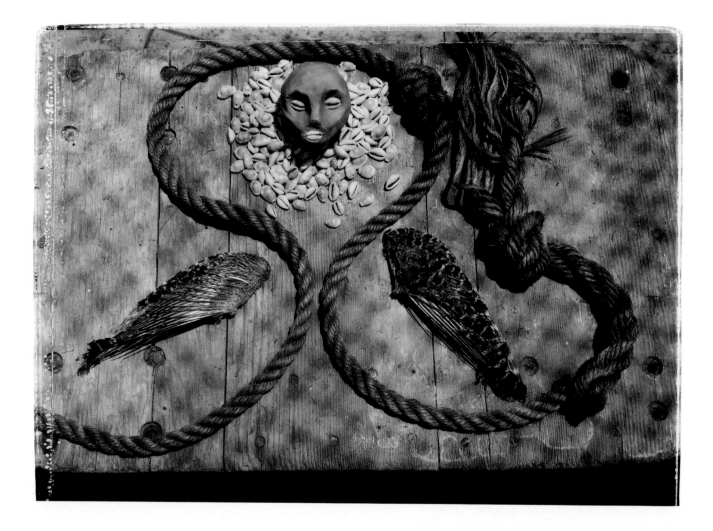

TRIBUTE TO PADRINO LOUIS, 1989

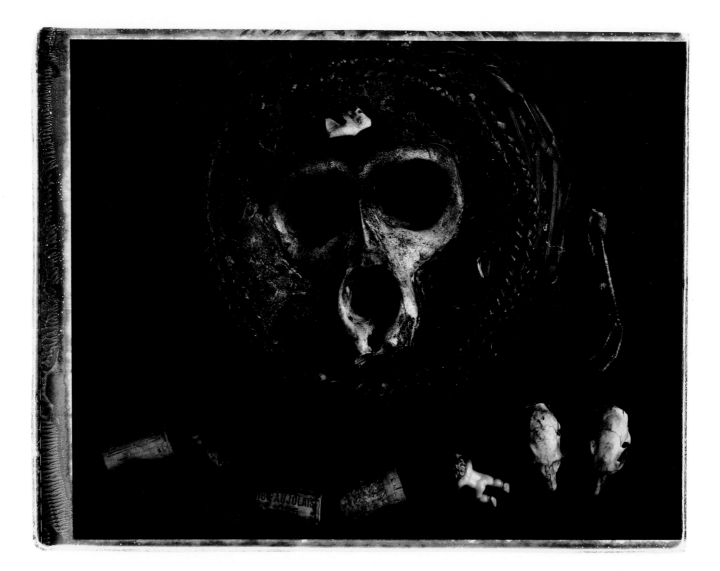

FOR BARON SAMEDI, 1987

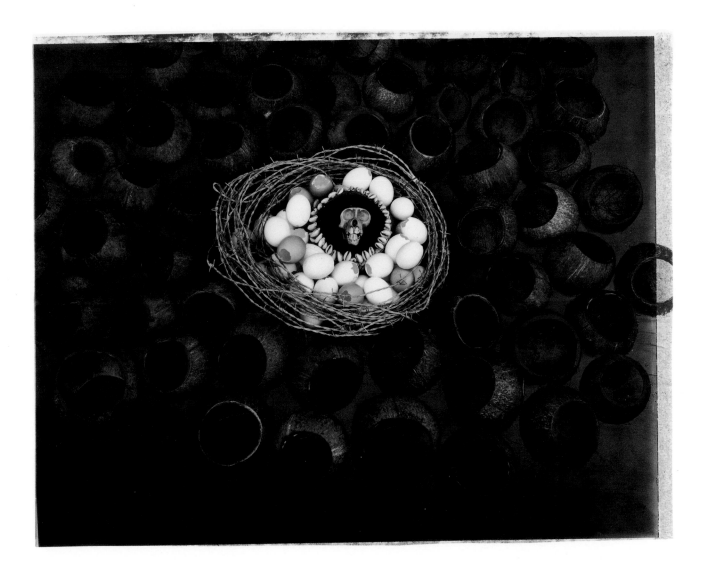

THE DERECHOS, 1991

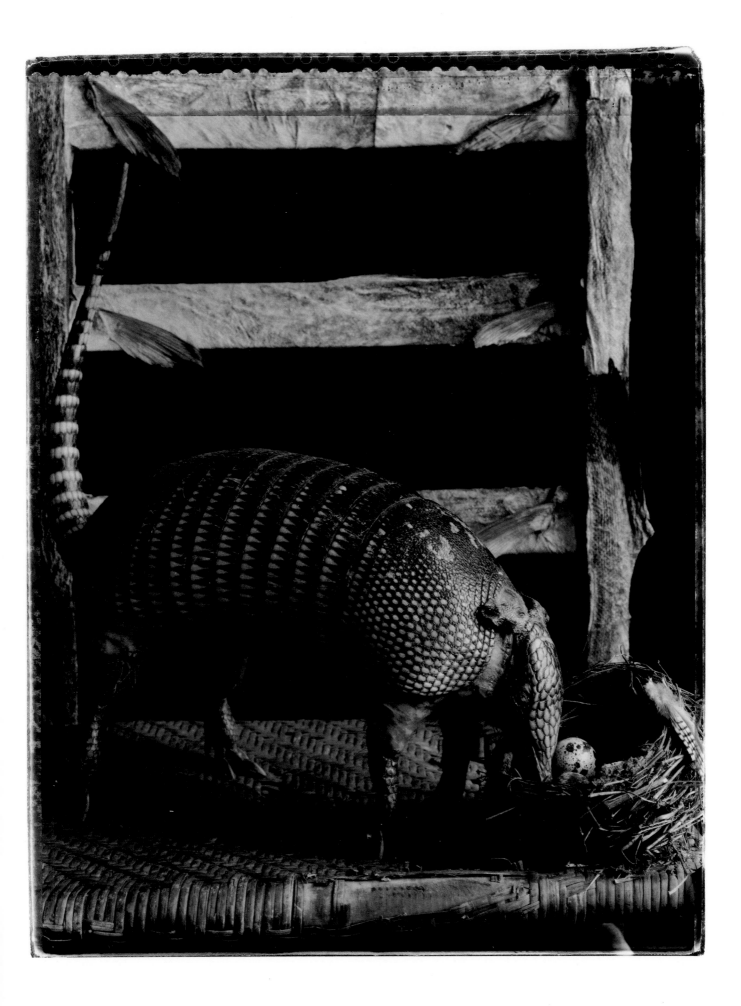

STEALING EGGS, 1987

∞ SEARCHING FOR THE SILKEN INVISIBLE, INTANGIBLE STRANDS OF DREAMS, OLD, VERY OLD, ANCIENT DREAMS OF A LIFE IN AFRICA, OF A LIFE IN CHINA. A LIFE AS A BUSHDOCTOR, AN OBEAHMAN, A MEDICINEMAN, A MYSTICAL WEAVER OF DREAMS INTO IMAGES. LIVES I LIVED BUT CAN NEVER REMEMBER, THE KISS I FELT BUT CAN'T RECALL.

THE RECENT DEATH OF MY FATHER CRYSTALLIZED FOR ME THE TENUOUS LINK I HAVE WITH THE PAST. WITH HIS PASSING I HAVE LOST THE MOST IMPORTANT LINK I HAD WITH MY PAST, A HISTORY ABOUT MYSELF AND MY FAMILY. I HAVE COME TO REALIZE THAT I AM A WALKING REPOSITORY OF CULTURAL, FAMILIAL AND GENETIC INFORMATION. THAT I SHARED WITH MY FATHER A CLOSER HISTORY THAN MY CHILDREN WILL SHARE WITH ME, AS THEIR UPBRINGING IN AMERICA WILL COMPROMISE A CULTURAL IDENTITY THAT GROWS MORE DISTANT WITH EACH GENERATION BRED ABROAD. I, LIKE OTHERS WHO TRACE THEIR ANCESTRY TO FOREIGN SHORES, AM DUTY BOUND AND RESPONSIBLE TO MY DESCENDANTS FOR PASSING ON MY PERSONAL AND FAMILIAL STORIES AND ULTIMATELY THE STORIES OF CULTURE AND RACE.

I GREW UP IN KINGSTON, JAMAICA. MY FATHER WAS A JUSTICE OF THE PEACE AND SERVED AS A JUDGE IN THE PETTY COURT. EVERYBODY CALLED HIM, SIMPLY, JUSTICE. REPUTED TO BE A FAIR MAN, HE WAS OFTEN CALLED UPON TO RESOLVE DISPUTES. ONCE, WE WERE ACQUIRING A NEW HOUSE IN ROCKFORT, A BEAUTIFUL PART OF KINGSTON THAT HUGS THE HARBOR. WANTING TO BLESS OUR NEW HOME, JUSTICE TOOK A WHITE CATHOLIC PRIEST WALKING WITH HIM THROUGH ITS ROOMS TO SPLASH HOLY WATER INTO THE CORNERS.

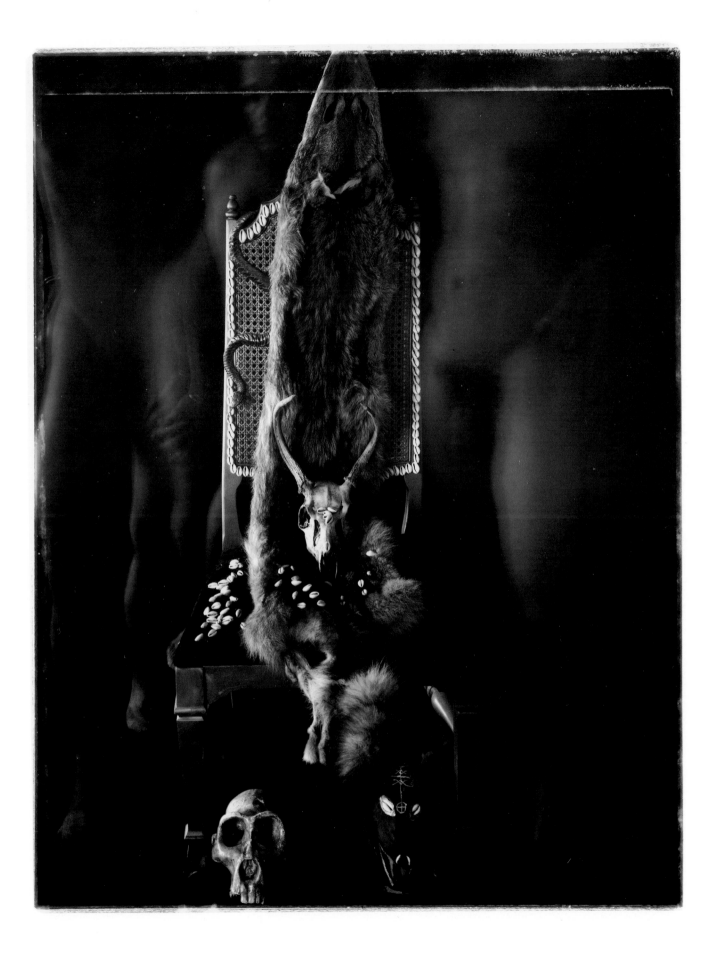

DANCING AROUND THE THRONE FOR ANTELOPE SPIRIT, 1992

A FEW DAYS LATER ANOTHER PRIEST CAME BUT THIS ONE WAS VERY DIFFERENT FROM THE LAST. FOR STARTERS HE WAS BLACK, VERY BLACK: HE GLOWED. HE HAD NO PRETENTIOUS ROBES, FOR HE WASN'T CATHOLIC. HE WAS AN OBEAHMAN. DRESSED IN FLOOD-LENGTH KHAKI PANTS, HE CARRIED WITH HIM A BURLAP BAG CONTAINING TWO YOUNG ROOSTERS. ALL MEMBERS OF THE FAMILY PRESENT WERE THEN CLEANSED BY RUBBING THE ROOSTERS ALL OVER OUR BODIES. THE ROOSTERS WERE THEN SWUNG AROUND THE ROOMS AND PRESENTED TO THE SPIRITS OF THE HOUSE. THEIR BLOOD WAS SPRINKLED INTO CORNERS, AROUND THE DOOR AND IN THE HEARTH.

IN BLESSING HIS NEW HOME, MY FATHER FELT THAT HE SHOULD COVER ALL HIS BASES, THAT HE SHOULD HONOR BOTH THE PRACTICES OF THE WHITE MAN AND THOSE OF THE AFRICAN. THE BELIEF IN THE SPIRIT FORCES PERMEATES ALL ASPECTS OF JAMAICAN LIFE. THESE SPIRITS, KNOWN AS DUPPY, ARE THE BASIS OF MANY OF THE STORIES THAT HAVE BECOME THE MYTHOLOGICAL BASE OF THE CULTURE. INDEED, IN MANY INSTANCES THE LINE BETWEEN MYTH AND REALITY IS LOST AND THE PEOPLE FEEL FREE TO MERGE THE TWO.

MANY SPIRITS, INCLUDING OGUN, OBATALA, SHANGO, ELEGUA AND OCHOSI, TO NAME A FEW, WERE CASTAWAYS ON THE MURDEROUS VOYAGES ACROSS THE ATLANTIC, AS AFRICANS WERE STOLEN FROM THEIR HOMELANDS TO BE SOLD INTO SLAVERY IN THE WEST. THEY REMAIN WITH US TODAY, IN THEIR MOST VISIBLE FORMS WITHIN VOODOO, SANTERIA AND CANDOMBLE. THESE POWERFUL COUNTERPARTS TO CHRISTIANITY AND CATHOLICISM PROVIDE A STRONG ALTERNATIVE FOR THOSE THAT TRACE THEIR ANCESTRY TO AFRICA, ALTERNATIVES THAT ARE VERY MUCH PART OF OUR HERITAGE.

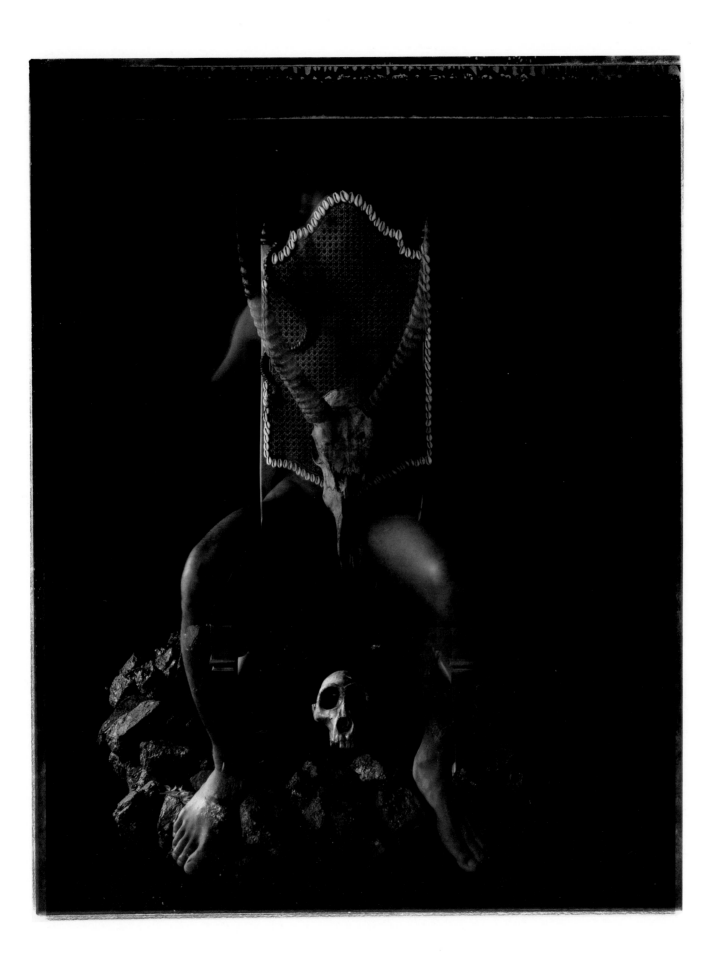

SEATED PRESENCE, 1992

THE SETTING ASIDE OF A FRACTION OF WHAT IS GAINED AS AN ACT OF THANKSGIVING IS AN ANCIENT CUSTOM PRACTICED BY PEOPLE ON BOTH SIDES OF THE COLOR LINE. IN JAMAICA, WHEN A BOTTLE IS PASSED, IT IS COMMON TO POUR SOME OF THE RUM OR WINE ONTO THE EARTH AS AN ACT OF ACKNOWLEDGMENT OF AND OFFERING TO THE SPIRITS OF THE BROTHERS AND SISTERS UNABLE TO PARTAKE. WITH THIS SIMPLE ACT, AN AGE OLD HUMAN CUSTOM IS REVIVED, AND OFFERINGS TO FORCES NAMED AND UN-NAMED REMAIN SUBLIMELY PART OF OUR CONSCIOUSNESS.

MY ANCESTRAL DIALOGUES ARE A CONSTANT DISCOURSE WITH THE SPIRITS OF THE PAST, AND A DAILY IMPROVISATION OF MY PRESENT LIFE. OVERALL, THIS WORK IS AN ATTEMPT TO FUSE THE PRACTICES INHERENT IN THE COSMOLOGICAL SYSTEM OF MY LIFE WITH THE ART MAKING PROCESS. TO ELIMINATE THE DISTINCTION BETWEEN ART AND LIFE, RITUAL, MAGIC AND MY OWN BRAND OF PERSONAL MYSTICISM. TO BRING HOME THE ANCESTRAL SPIRITS, AND SEAT THEM ON THE THRONES THAT HAVE BEEN CREATED FOR THEM, UPON AND ABOUT WHICH OFFERINGS ARE MADE TO THEM.

THEIR PRESENCE I CONJURE TO THE DINNER TABLE, WHERE THE SUNDAY DINNER IS OFFERED, THE CIGARS HAVE BEEN SMOKED AND THE RUM HAS BEEN SIPPED. ∞ A.C.

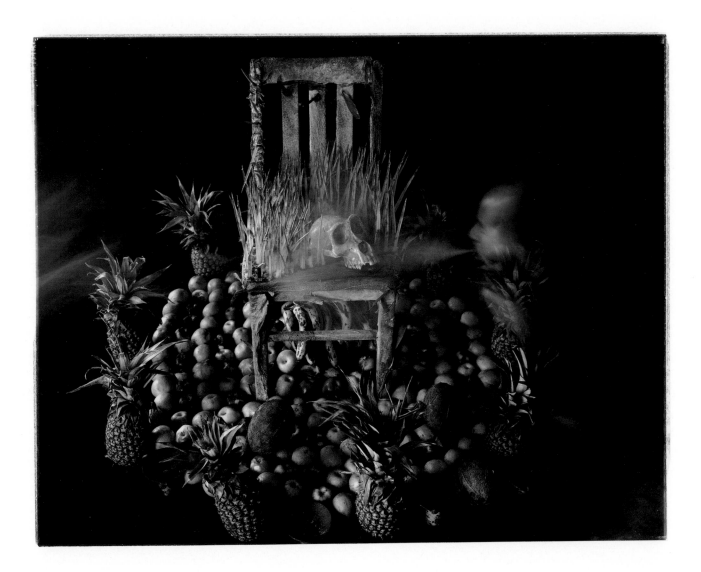

BLESSING THE THRONE FOR GORILLA SPIRITS WITH CIGAR SMOKE, 1992

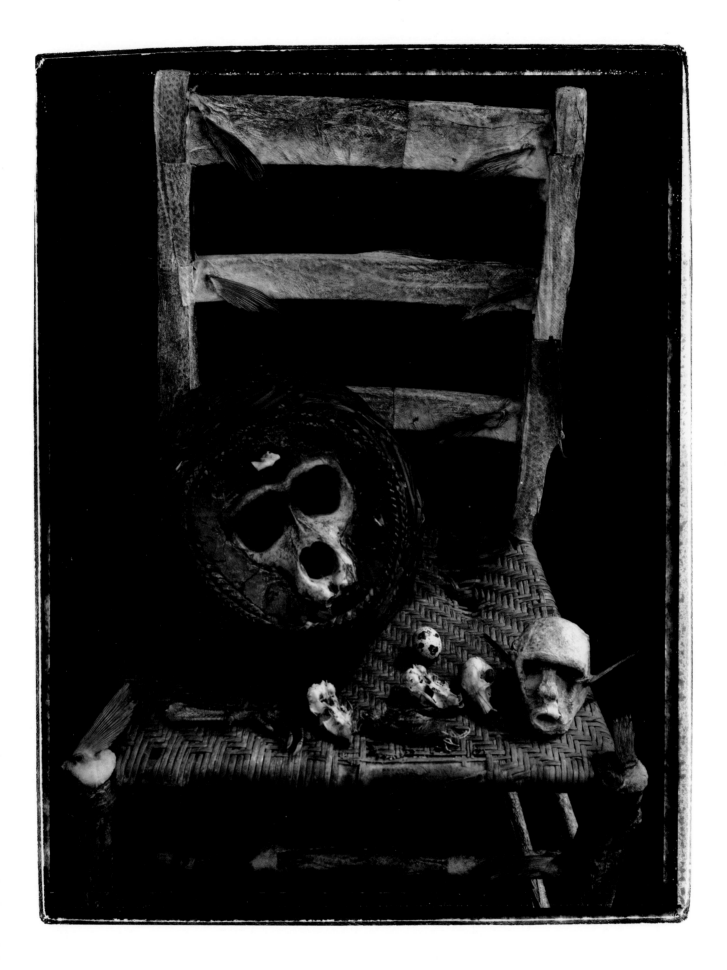

THRONE FOR THE ANCESTORS, 1987

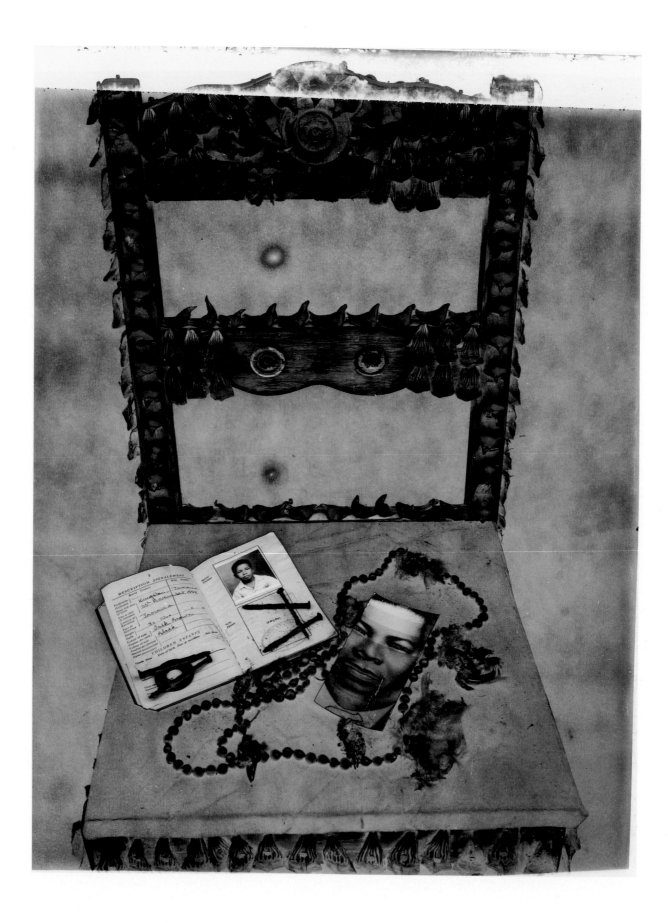

THE TWO GENERATIONS, 1990

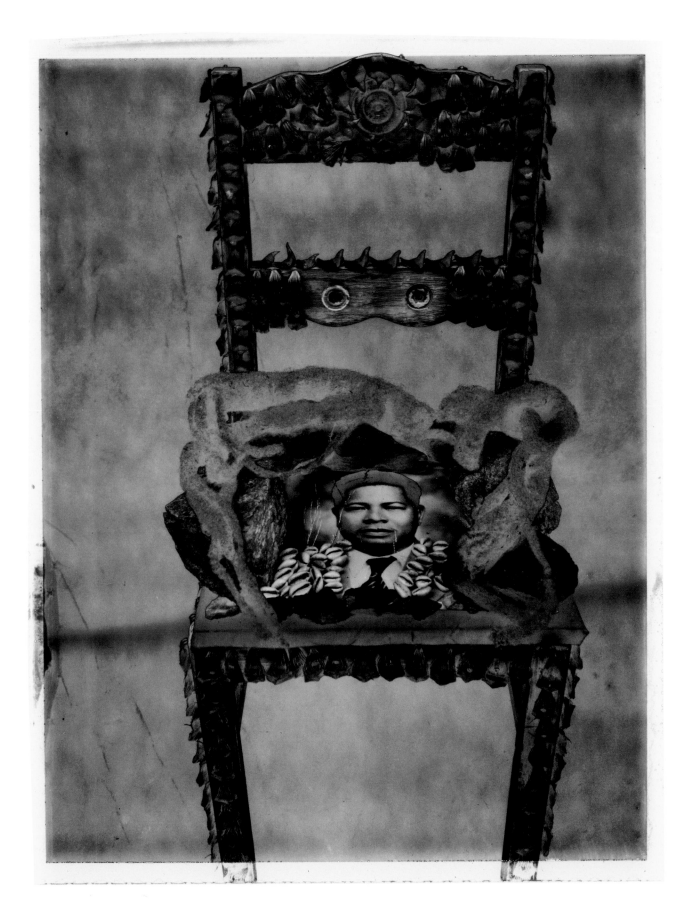

THRONE FOR THE JUSTICE, 1990

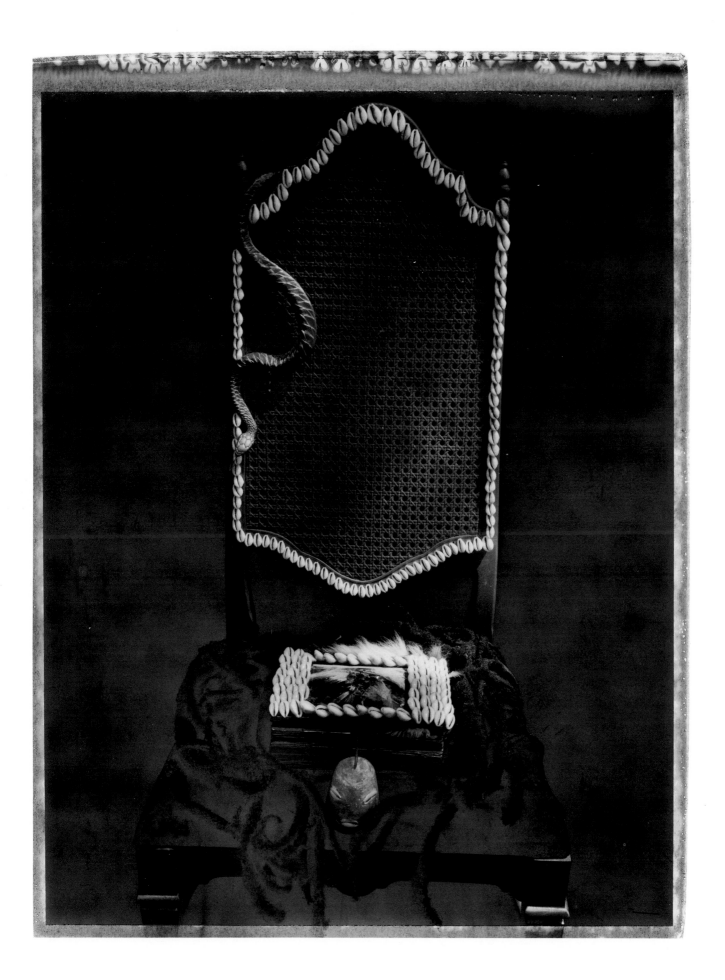

THRONE FOR ELEGUA WITH NAMING BOOK AND SOLARIZED DREADLOCKS, 1990

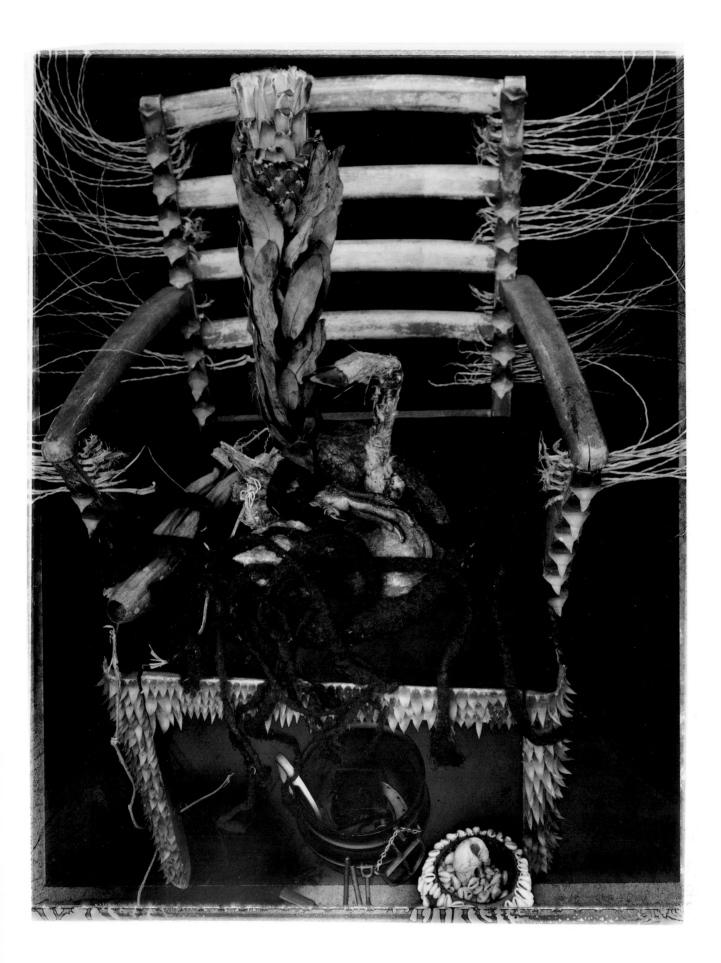

For Ogun With Deer Hoof, Claw, Dreadlocks and Plant, 1990

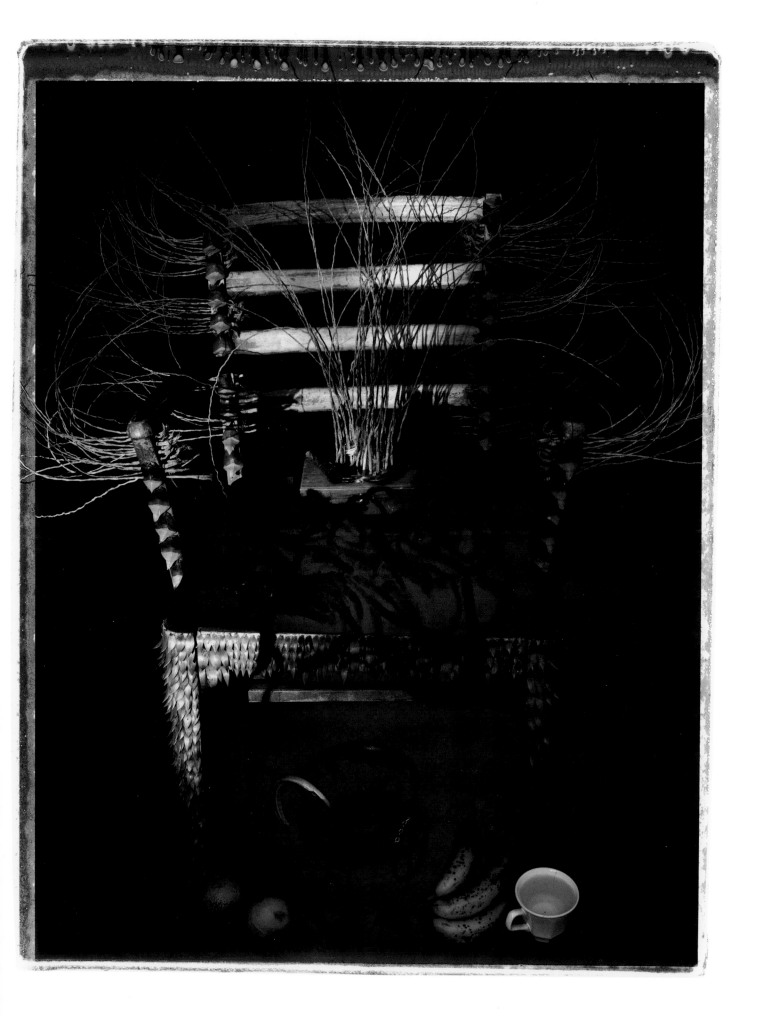

THRONE FOR OGUN WITH SPIRIT BOX, DREADLOCKS AND OFFERING, 1990

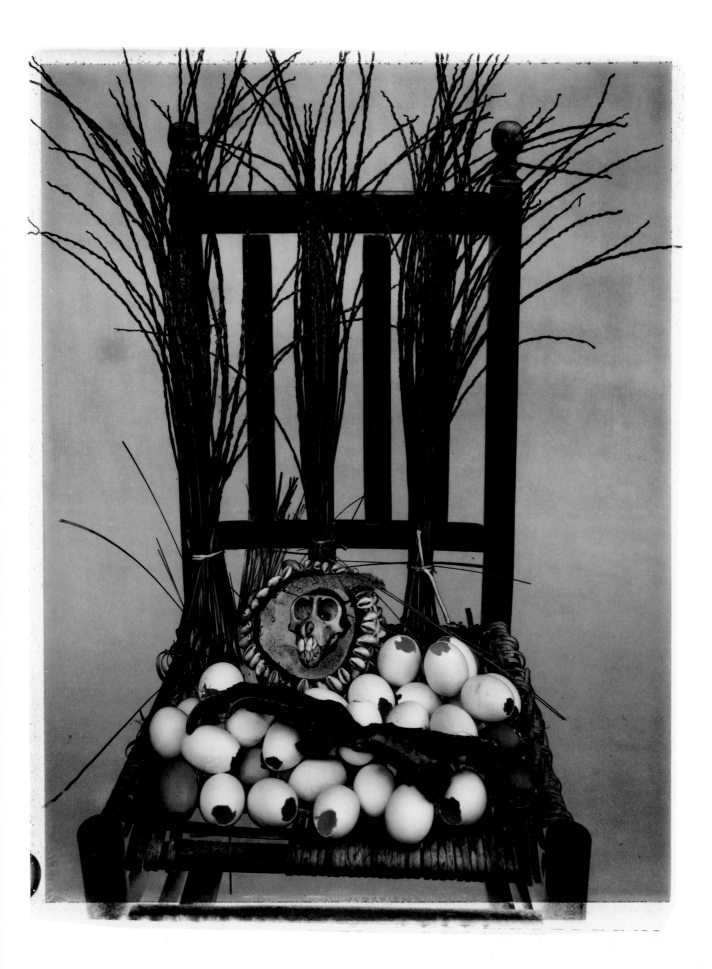

THRONE FOR THE KEEPER OF THE BONEYARD, 1991

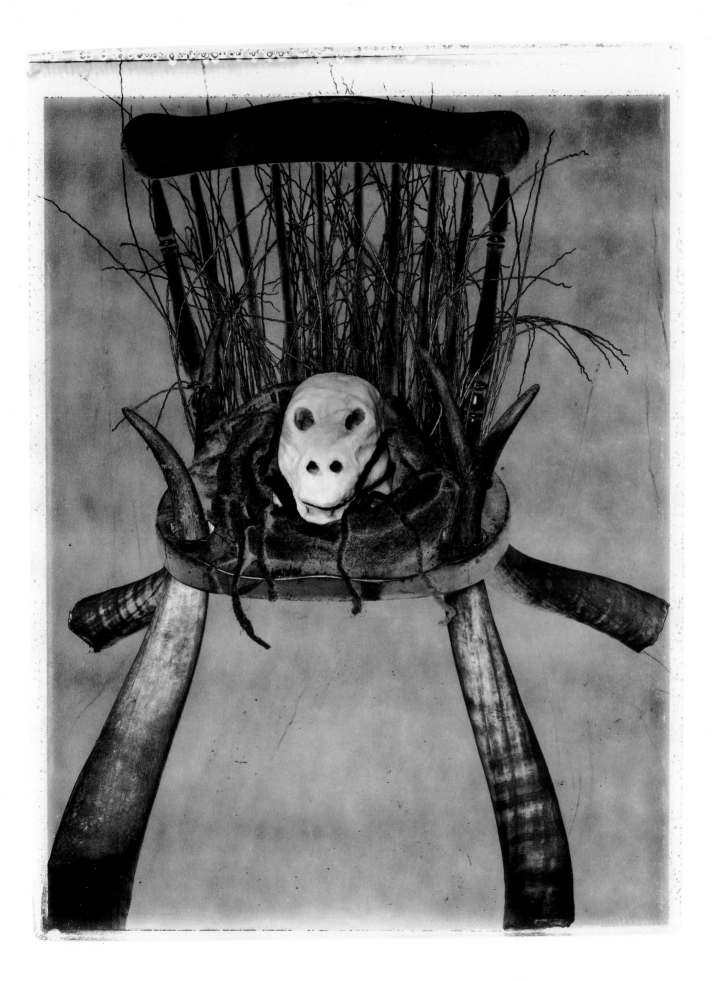

THRONE FOR MR. BAKER, 1990

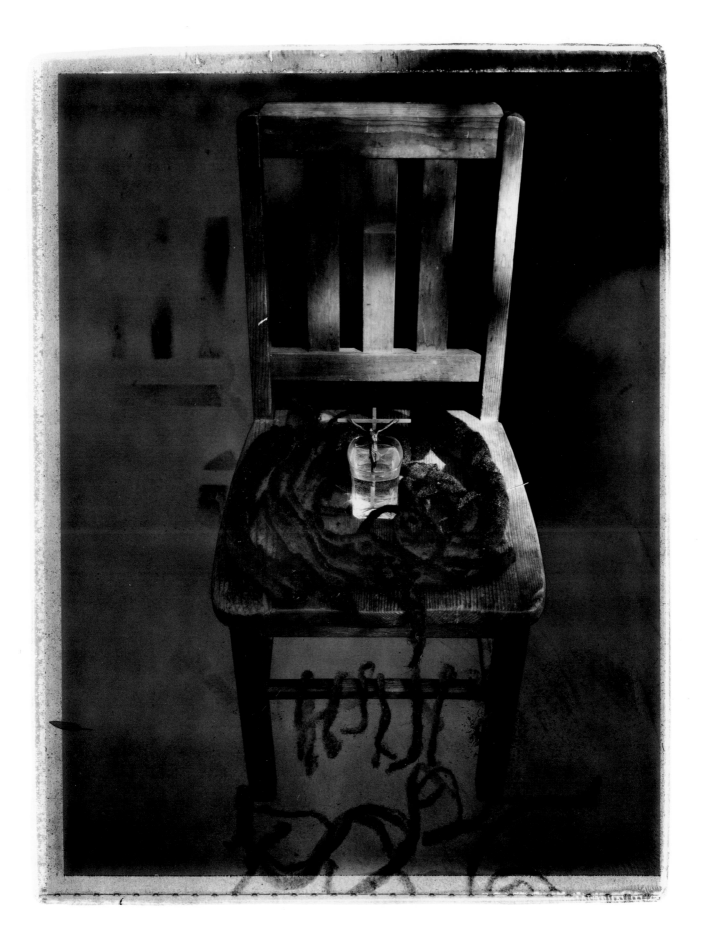

UNTITLED THRONE WITH CRUCIFIX, WATER AND DREADLOCKS, 1990

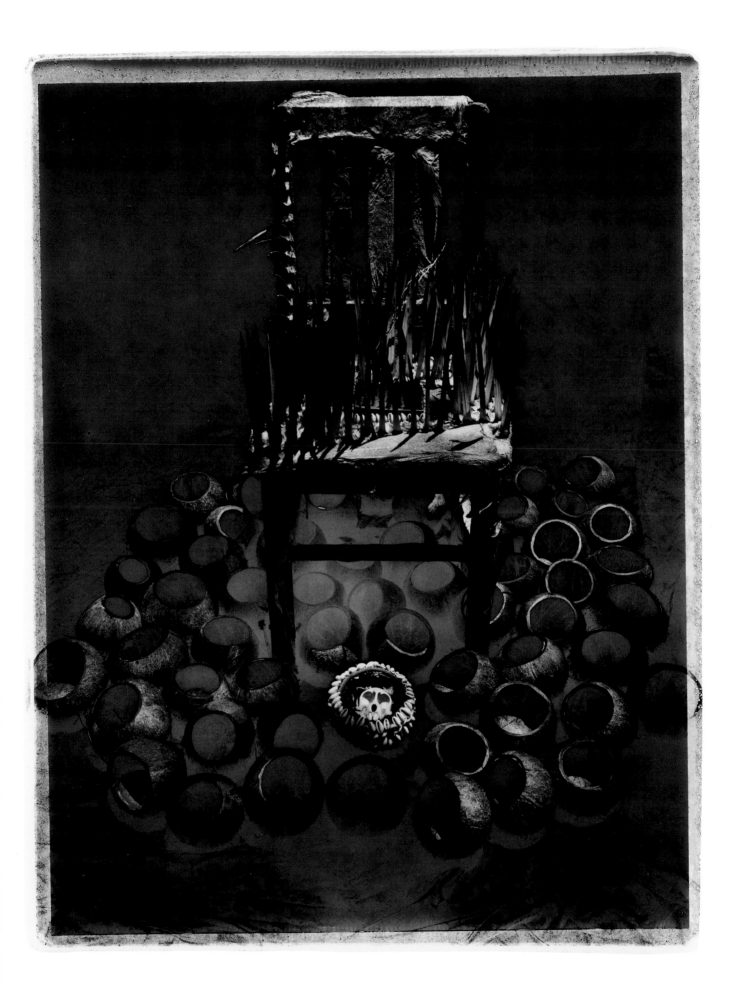

CODFISH THRONE WITH DREADNUTS AND JOSHUA TREE SPINES, 1991

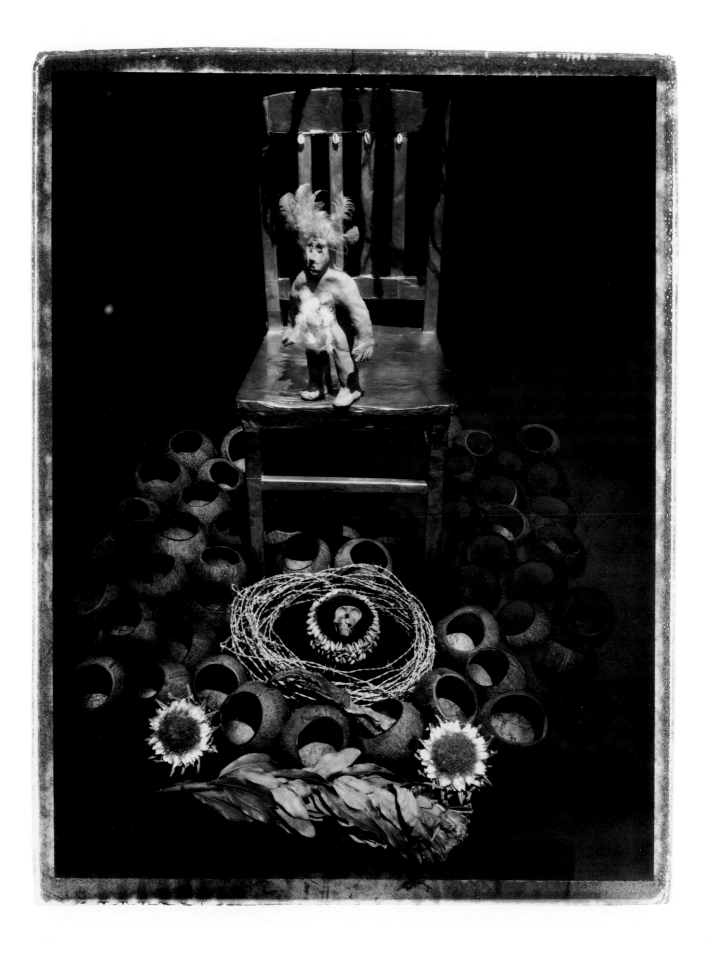

COPPER THRONE WITH FEATHERED CLAY FIGURE, 1991

∞ ALBERT CHONG:
EYE & I

By Thelma Golden

∞ Photographs are traditionally viewed as the literal embodiment of what is visible; Albert Chong seeks to make manifest what is invisible. His photographs remind me of things I have never really seen, and yet everything is hauntingly familiar. At some level, experiencing his work involves suspending and confronting the knowledge of science—and believing in the potency of magic. It is the precise intermingling of these two forces which converge to capture the moment and bear its essence. Albert Chong's photographic practice relies on his mastery of science and his surrender to the sources he seeks to render visible.

Located within the complex relationship between photography and identity, Chong and his work are firmly rooted in the contemporary practice of incorporating a diversity of cultural influences into the art making process. This hybridity, however, is not one of warring, incongruous parts; it is forged from what art historian Robert Farris Thompson calls "the ecstasies of cultures recombined."[1]

Chong, transplanted from Jamaica to New York, has enabled the components of these divergent cultures to make peace as they negotiate their way into his art. The camera functions as an extension of this artist's psyche; it allows him to piece together history and biography while simultaneously examining culture through the refracted lenses of time and distance. Personal rituals,

even those as familiar and necessary as eating, provide a source from which Chong translates memory into art. In this spirit, Chong introduces elements from his diet into his images. Of this particular connection between his life and his art, Chong says:

Cooking and eating the food I grew up with is a way to connect with the past. As a Jamaican living abroad, one concerned with maintaining a national identity separate from the mainstream, salted codfish assumes a place of importance in my diet. It is an integral ingredient of the Jamaican national dish, and was readily available in my neighborhood. When I would cook it on Sundays, I would separate the skin carefully from the flesh. Eventually books, boxes, a walking stick and chairs were covered with codfish skin. I also kept the remains of the food I ate such as coconuts and eggshells and recycled them into the work. [2]

In this spirit, his home, family and the land have created a critical nexus from which Chong connects old and new, past and present. Acknowledging the persistence of African culture throughout the "New World" brings further understanding to Chong's project. While it has long been popular to overtly idealize one's African past, this artist's relationship to Africa is experiential and intuitive. The vestiges of these Africanisms, which survived the Middle Passage to reform themselves in the Americas, make their presence known throughout his work.

In embracing this expansive world view, the work captures many dualisms, apparent both in the process of the pictures and in the ideas which inform the work. Chong's conceptual approach provides an example of one of the fundamental tenets of the "new" photography, which curator Lisa Phillips qualifies as the shift from the "taking" to the "making" of photographs.[3] Black and white, light and dark, here and there—they all exist in the comfortable contradictions that are inherent simultaneously in contemporary culture and aesthetic models. Underlying these contentions is an attention to the intellectual formation of image and idea. In describing the intellectual obsessions of Afro-Caribbean painter Jean-Michel Basquiat, cultural critic Greg Tate defines these formations as: "...ancestry and modernity, originality and the origins of knowledge, personhood and property, possession (in the religious sense) and slavery."[4] These obsessions also concern Chong as he and Basquiat both work to combine African diasporic references with a newly defined identity.

Working around an aesthetic which strives to connect and construct, Chong and his work are formally and thematically linked to a multitude of photographers and artists. The construction of his environments are reminiscent of the ironically-stated tableaus of Laurie Simmons' photographs, and his positioning of himself in a variety of roles recalls Cindy Sherman's film stills. His employment of mystery and the magical, and his involvement in African-derived religious systems recalls Ana Mendiata's photographs of herself and the manipulated landscapes in which she performed rituals and documented them, as well as Betye Saar's sculptures which assemble personal artifacts and found objects. The reverence for natural materials and their inherent power echoes Georgia O'Keeffe's idealization of the natural environment of the Southwest as well as the visual power of that landscape captured in the images of

Richard Misrach. Chong's documentation of ritual and action relate to Vito Acconci's photographic documents and Adrian Piper's performance-oriented images. He shares an obvious zeal in identifying the complexity and repositioning of African American culture with contemporary photo/text artists Lorna Simpson, Carrie Mae Weems and Pat Ward Williams. He is an artistic shaman like David Hammons, coaxing the power out of the profane.

Spanning Chong's career, the photographs in this volume are divided by genre: the self portraits, or "I-Traits"; rephotographic works in which Chong incorporates found photographs; and still-lifes, which include the "Thrones for the Ancestors." While they are organized thematically, the photographs illustrate the artist's concurrent and ongoing concerns and transcend their thematic arrangement. They range in size and process, evidencing Chong's diverse stylistic impulses. Scale is carefully juxtaposed with issues of tone, light and dark. The surface of these prints, with their tacit two-dimensionality, belies the depth and tactile nature of the objects captured.

An interest in portraiture as it is most broadly defined is paramount to much of his work. The "I-Traits," made in the years 1980-85, most specifically and personally encompass Chong's involvement in the representation of the self. These images, in Chong's words, are "a personalization of an Afro-Caribbean, Rastafarian mystical world view."[5] The "I" in their title refers to the concept of self in the Rastafarian system of belief.[6] Rastafarianism, simply defined, is a spiritual movement with roots in ancient Ethiopia, which burgeoned in Jamaica in the middle of this century. As defined by Horace Campbell, Rastafarianism challenges the history of slavery and the reality of white racism, while emphasizing the permanent thrust for dignity and self-respect among Black people.[7]

In these portraits Chong extensively elaborates on notions of selfhood. He uses his body to insinuate a variety of roles, fictional and real, contemporary and historical. Some of the photographs, like *Leaning On The Palo,* suggest ritual without claiming specificity, relying on the potent associations of the objects. Composition and form dominate to evoke emotion and action. In others, like *The Fire Keeper Dancing With The Flames* and *Dancing With The Palo,* Chong enacts a ritualized action. As he positions them within his desire to re-connect with his ancestral past, he describes these images as documents of ritual. All created in front of a neutral backdrop of wrinkled burlap sackcloth, these images obliterate any sense of moment or place, achieving what critic Lucy Lippard calls "inter-subjective time."[8] Time exists without a context. Due to long exposure times, Chong's body most often appears in these images as an apparition-like blur. In some, the apparition is collapsed into a presence connoted by quickly dispersing smoke.

The reclamation of the self in art often involves the recreation of a lost past or of a social position. In Chong's case, much of the work resonates with the impulse towards the recognition of nobility. This concern, existent throughout African-American art and culture, is shared with other artists, such as writer James Baldwin who spoke of the absolute necessity for African Americans "to wear the crown."[9] In this spirit, painter Jean-Michel Basquiat punctuated his paintings with crowns and references to regality.[10]

For Chong, this impulse is perhaps most evident in his "Thrones for the Ancestors." Linking this concern to his Afro-Caribbean heritage, art historian Kellie Jones states:

Chong's current preoccupation with thrones and chairs is of special interest given his Jamaican background. Jamaica is the new world stronghold of the Akan culture of West Africa. The Ashanti, as part of the Akan cultural group, *have a great veneration of their sacred stools, which also serve as altars.[11]*

In contrast to the literal, self-inclusive, performative impulses of the "I-Traits," the "Thrones for the Ancestors" are spiritual portraits which encompass more emotion than gesture. Perhaps most emblematic of these works are those made for the artist's late father, who was a Justice of the Peace in Kingston, Jamaica, and was known, simply, as Justice. Henceforth, "justice" became an integral and identifying characteristic of his persona.[12] The incorporation of an image of his father characterizes many of these images, as seen in the photograph *Throne For The Justice.* Surrounding the image, which sits on the seat of a heavily embellished chair, is the skeletal image of a cloak of dreadlocks. The image of Justice recurs throughout many works, until "justice" becomes a connection between personal and political concerns.

While his father's physical presence marks some of these works through Chong's centralized use of his image, other thrones conjure specific spirits. The constituent ideas which inform "The Thrones for the Ancestors" are intertwined with Chong's consistent reckoning with death and desire for communion with his ancestors. While the "Justice" subtext embraces a literal homage to his father, a more metaphoric exploration of his ancestry moves throughout Chong's various genres.

The spirits, or the *orisha* as they are called in Yoruba culture, appear as the specific link to Africa in the images in both literal and metaphoric forms.[13] *Throne For Ellegua With Naming Book* refers to the orisha also known as Eshu-Elegba, the orisha of the crossroads.[14] Significant to this image is the small, carved image on the seat of the throne. This object is an example of the devotional objects made to worship Elegba, who is seen to have far-reaching powers embodied in his role as messenger to the

Gods. Chong also incorporates a snake, which winds up the side of the throne and refers to the animal personifications of the pantheon of Yoruba deities. The cowrie shells, which appear in this image and punctuate the compositions of many works, were used as currency in Yoruba culture and are still used in rituals and as a culturally specific decoration.

The orisha Ogun is explored in the *Throne For Ogun.* Ogun is the god of iron and war and is credited for creating the world. He is specifically associated with the cutting and slashing motions symbolic of destruction. Chong captures this force in the sharp edges which embellish the throne and the animated fronds which sit on its chair. Surrounding the fronds are an arrangement of dreadlocks, Chong's encoded sign of the personal. Using re-photography and a solarization of the negatives, Chong takes these images from the sublime to a heightened contrast in which aspects of the composition appear in x-ray. These techniques combine effectively to convey the power of the medium as well as that of the spirits. The more stylized thrones, including *Joshua Tree Spines* and *Copper Throne With Feathered Clay Figure,* encompass the old and the new, the found and fashioned, the natural and manmade; they are highly personalized statements for the ritual of remembrance.

Ancestor worship is evident in varying permutations in all of the cultures Chong exists within and looks to for inspiration. Many of his images contain offerings placed in front of or around the thrones. His newer installation works, such as *Sunday Dinner For The Ancestors* (which Chong mounted at Angels Gate Cultural Center in San Pedro, California, in 1991), render these altars three-dimensional and environmental in the interest of honoring the spirits. African and Asian cultures, and their resultant hybrids in the Caribbean, all venerate the spirits with rituals that involve preparing offerings for and consulting with the spirit world as a necessary part of every-

day life. African and Caribbean-based theological traditions such as Santeria, Voudun, Yoruba, and Rastafarianism are based on ideology which embraces a belief in the connection between the physical and the spirit world. Those who enable the connection are both sacred and profane. They are the shaman and the Obeahman, the channel and the diviner.[15]

Using his camera as a tool to entrance, Chong mediates the worlds of life and death in his imagemaking. Photographer Victor Masayesva says: "Photography reveals to me how it is that life and death can be so indissolubly one; it reveals the falseness of maintaining these opposites as separate. Photography is an affirmation of opposites. The negative contains the positive." [16]

The ever-present concern with the spiritual coincides with much of the theory around photography and its varying uses. In discussing the nature of photography as it is used to objectify native cultures, Masayesva relates the commonly held idea that the act of taking one's physical likeness through photography is tantamount to stealing one's spirit.[17] Chong intervenes into the center of this debate in his practice. Concurrently, however, there is a contemporary acknowledgment of the power of the photographer and the ability to create truths via objective presentation. Like present day shamans, photographers make and create images both literally and figuratively. Masayesva describes the possibilities of photography as: "...ceremony, as ritual, something that sustains, enriches, and adds to our spiritual well being."[18] In his project, Chong works within a traditional photographic framework while acknowledging Masayesva's stated possibilities for the role of the photographer in the contemporary moment.

While Chong has created a vocabulary that encompasses a variety of forms, his work is unified by a visual system he creates through the meanings inherent in his

materials. His personal iconography is derived from a cosmology which combines the varying cultural and theological traditions with which he identifies. Consistent to the works is Chong's role as a mediator (or, more specifically, diviner) of all of these objects; he cloaks their visual potential. He is fascinated with the symbolic properties of containers and casings. Eggshells, calabashes and seashells populate the photographs. Carcasses, in varying states of decay, connote death and life simultaneously. Chong also records the beauty of natural things in relatively unaltered states: Joshua Tree spines, condor claws, flowers and fruit. Most resonate are those things that are personal; his dreadlocks, various mementos of the artist's family and friends. Even the found objects (dolls, empty bottles, corks, silverware, rope) are stripped of their banality and vulgarity and utilized for their evocative properties. As cultural critic Greg Tate writes: "We live in a world of signs and ciphers we manipulate to perform symbolic magic of our own device."[19]

Photography remains a contested site. More than 150 years after its invention, the definition of what is and what isn't photographic remains unclear. Working both in and outside the debate, Chong incorporates the technical and the conceptual, the cultural and the aesthetic in his ongoing exploration into the medium. Robert Farris Thompson identifies in his writings what he describes as "the flash of the spirit."[20] This flash exists in the photographs of Albert Chong as if it were born in the volatile combination of their emulsion.

The Rastafari refer to the self in the plural as the all inclusive "I and I." This term encompasses the essence of the self which is the body, as well as the self that is the spirit inherent in everyone; the veritable confluence of the body and the spirit. For Chong in his ongoing exploration of process and the personal, his spirit comes through the camera. His eye is the "I"; body and spirit, art and idea in communion. I and eye. ∞

NOTES

1. Robert Farris Thompson, "Royalty, Heroism, and the Streets: The Art of Jean-Michel Basquiat" in *Jean Michel-Basquiat,* exh. cat. (New York: Whitney Museum of American Art, 1992), p. 36. Thompson is the author of several seminal texts on African and African-American art.

2. Artist's text, unpublished manuscript, 1993.

3. Phillips talks about this debate in Lisa Phillips, *Photoplay: Photography and Contemporary Art* (New York: Chase Manhattan Bank, 1993), p. 11.

4. Greg Tate, "Black Like B." in *Jean-Michel Basquiat,* p. 56.

5. Artist's text, *op. cit.*

6. I am indebted to Gary Simmons for my understanding of the nuances in these concepts.

7. I have compressed a complex history and set of ideas into a few descriptive sentences. This definition of Rastafari is a synthesis of Horace Campbell's work on the topic. Horace Campbell, *Rasta and Resistance* (Trenton, N.J., Africa World Press, 1987).

8. Lucy Lippard, ed. *Partial Recall: Photographs of Native North Americans* (New York: The New Press, 1992), p. 37.

9. Often invoked by Baldwin in lectures attended by the author at Amherst College in 1983.

10. See images in the aforementioned *Jean-Michel Basquiat.* Also referenced in the essays on Basquiat by Robert Farris Thompson and Greg Tate.

11. Kellie Jones, *Interrogating Identity,* exh. cat. (New York: Grey Art Gallery, 1991). As the curator of *Interrogating Identity,* as well as other exhibitions which have included Chong, Jones has played a critical role in the exhibition and interpretation of Chong's work.

12. Artist's text, *op. cit.*

13. My entire understanding of Yoruba culture specifically and African cultural forms generally comes from Robert Farris Thompson, *Flash of the Spirit: African & Afro-American Art & Philosophy* (New York: Vintage Editions, 1984). See Thompson for an indispensable discussion of Yoruba culture.

14. The spellings of the orishas vary. I have followed Thompson's spellings, which sometimes differ from the artists'.

15. Obeah is a practice which encompasses medicine, magic, science and religious beliefs transferred from person to person by those initiated into the practice.

16. Victor Masayesva, in Victor Masayesva and Erin Younger, eds., *Hopi Photographers/Hopi Images* (Tucson: Sun Tracks and University of Arizona Press, 1983).

17. *ibid.*

18. *ibid.*

19. *Jean Michel-Basquiat,* p. 56.

20. This is the essence of the aforementioned text, *Flash of the Spirit.*

PERSONAL
Born November 20, 1958, Kingston, Jamaica, West Indies.

EDUCATION
BFA, School of Visual Arts, New York City, 1981.
MFA, University of California, San Diego, 1991.

SELECTED GRANTS AND AWARDS
1993: Travel Grants Pilot Fund, Arts International and NEA.
1992: National Endowment for the Arts, Individual Artist Fellowship.
1991: National Endowment for the Arts Regional Fellowship, Western States Arts Federation.
1990: California Arts Council Individual Artist Fellowship.
1982: CAPS Photography Fellowship, Creative Artist Program Service Grant, New York City.
1977: Silver and Bronze Medals for Photography, Jamaica Festival of the Arts, Kingston, Jamaica.

SELECTED SOLO EXHIBITIONS
1994: *Ancestral Dialogues.* The Ansel Adams Center for Photography, San Francisco, Calif.

1993: *Albert Chong: New Works.* Porter Randall Gallery, La Jolla, Calif.

 YIN/YANG, US/THEM, BLACK/WHITE, GOOD/BAD. Installation. Bronx Museum of Art, Bronx, N.Y.

1991: *Homecoming: New Photography.* Chelsea Galleries, Kingston, Jamaica.

 Sunday Dinner for the Ancestors. Installation. Angels Gate Cultural Center, San Pedro, Calif.

 Blood is Thicker. Installation. Southwestern College Art Gallery.

1990: *A Substitute Sacrifice.* Installation. Kruglak Gallery, Mira Costa College, Oceanside, Calif.

 Healing the Cross, Healing the Symbol: A Substitute Sacrifice. Installation. The Mandeveille Annex Gallery, University of California, San Diego.

1981: *Dread In Exile.* School of Visual Arts, New York City.

SELECTED GROUP EXHIBITIONS
1993: *Ritos Vivos (Living Rites).* Carla Stellweg Latin American & Contemporary Arts, New York City.

 Ancestral Spirits. El Camino College Art Gallery, Torrance, Calif.

 There Is A World Through Our Eyes: Perceptions and Visions of The African American Photographer. Rockland Center For The Arts & Blue Hill Cultural Center, Rockland County, New York.

 Inside the Black Experience. Union Gallery, University of Arizona, Tuscon.

1992: *Counterweight: Alienation, Assimilation, Resistance.* Contemporary Arts Forum, Santa Barbara, Calif.

 Persona. Museum of Photographic Arts, San Diego, Calif.

 Images and Objects. Porter Randall Gallery, La Jolla, Calif.

1991: *The Pleasures and Terrors of Domestic Comfort.* Museum of Modern Art, New York City. Travelling exhibition.

 Interrogating Identity: The Question of 'Black' Art. Grey Art Gallery and Study Center, New York University. Travelling exhibition.

1990: *Convergence.* Photographic Resource Center at Boston University, Boston.

 The Decade Show. The New Museum of Contemporary Art, New York City.

1989: *New Photography: Constructed Images.* Studio Museum, Harlem, New York.

 American Pictures of the 1980's: The Photography of Invention. National Museum of American Art, Smithsonian Institution, Washington. Travelling exhibition.

1987: *Inaugural Exhibition.* Harlem Renaissance Gallery, New York City.

Large as Life. Jamaica Arts Center, Queens, New York. Travelling exhibition.

1986: *Myth and Magic, Offerings and Amplifications.* Henry Street Settlement, New York City.

1984: *Contemporary Afro-American Photography.* Allen Memorial Art Museum, Oberlin College, Oberlin, Ohio. Travelling exhibition.

1983: *14 Photographers.* Schomburg Center For Research in Black Culture, New York City.

1977: *Festival Photography Exhibition.* Jamaica Festival of the Arts, Kingston, Jamaica.

SELECTED BIBLIOGRAPHY

"Men's Look at Men Has Blind Spot." Susan Freudenheim, *The Los Angeles Times,* San Diego Edition, March 3, 1992.

"Letter From New York, No. 29." A.D. Coleman, *Photo Metro,* 1992.

MoMA Members Quarterly (The Members Quarterly of The Museum of Modern Art), No. 9, Fall, 1991.

Pleasures and Terrors of Domestic Comfort. Peter Galassi, The Museum of Modern Art, New York, 1991.

Interrogating Identity. Exhibition catalog. Grey Art Gallery and Study Center, New York University, 1991.

"How Racial and Cultural Differences Affect Art." Charles Hagen, *The New York Times,* August 23, 1991.

"Aesthetic intellect, pulsing emotion blend in Convergence." Kelly Wise, *The Boston Globe,* January 25, 1991.

Exposure, A Publication of the Society for Photographic Education, Kellie Jones Selects, Volume 27, no. 4.

ZYZZYVA, Vol. vii, no. 1, Spring 1991.

"Interrogating Identity: The view from outside." Christine Temin, *The Boston Globe,* December 28, 1990.

Mixed Blessing: New Art in a Multicultural America. Lucy Lippard, Pantheon Books, 1990.

"Sacred Meets Profane Via Sacrifice." Leah Ollman, *The Los Angeles Times,* October 4, 1990.

"Artist's Work Rejects Black Life." Joanne Milani, *The Tampa Tribune,* February 12, 1990.

An Illustrated Bio-Bibliography of Black Photographers, 1940-1988. Deborah Willis-Thomas, Garland Press, New York, 1989.

"Rise Of A New Black Culture, Cult-Nats Meet Freaky-Deke." Gate Tate, *The Village Voice Literary Supplement,* December, 1991.

"Lehman Shows Products Of Bronx Alternative Spaces" Vivian Raynor, *The New York Times,* May 10, 1987.

"The Mind's I, Part 4." Catalog essay. Russell Leong, Asian Art Institute, New York City, 1987.

Large as Life Contemporary Photography. Brochure. Kellie Jones, Jamaica Arts Center, Jamaica, New York, 1987.

"Seeing is Believing." O'Reilly, *The Village Voice,* January 14, 1986.

"Seeing is Believing." Catalog essay. Alternative Museum, New York City, 1985.

"Contemporary Afro American Photographers." Catalog essay. William Olander, Allen Art Museum, Oberlin College, 1984.

"14 Photographers." Catalog essay. Deborah Willis-Thomas, Schomburg Center for Research in Black Culture, New York City.

GALLERY REPRESENTATION

Porter Randall Gallery, LaJolla, Calif.

Catherine Edelman Gallery, Chicago.

Carla Stellweg Latin American and Contemporary Art, New York City.

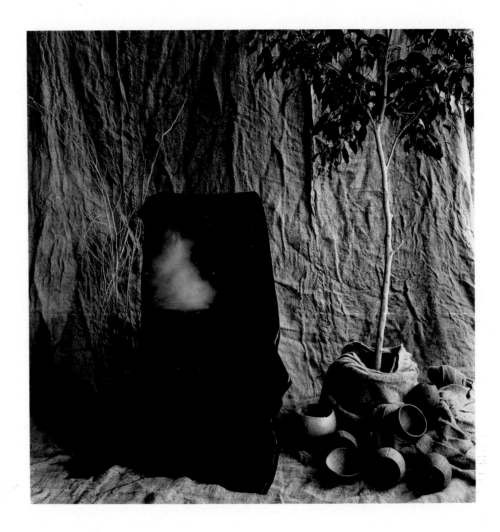

ISHENCE (ICIENCE), GANJA SMOKE ON BLACK VELVET CHAIR, 1982